J. GARCIA

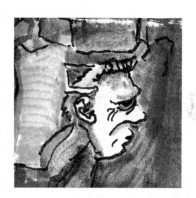

J. GARCIA

Paintings, Drawings and Sketches

Edited by David Hinds

CELESTIALARTS

Berkeley, California

ACKNOWLEDGMENTS

Design: David Charlsen
Color Separations: Repro-Media
Most Honorable Delphi: Bruce Stilson
Facilitator: Manasha Matheson
Family Historian: Leonor Ross
Communication: Vince Di Biase
Conveyance: Leon Day
Composition: ImageComp
Production: Nora Sage

FIRST PRINTING 1992

ISBN: 0-89087-654-1 (paper)
 0-89087-681-9 (cloth)
 0-89087-682-7 (limited edition)

Library of Congress Catalog Card Number: 92-072066

1 2 3 4 5 6 7 8 9 10 / 96 95 94 93 92

Printed in Singapore

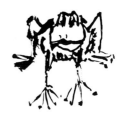

For Manasha,
with Love,
Jerry

Paul Gauguin was an accomplished piano player. He also played the mandolin. Woody Allen plays clarinet in a jazz band on Friday nights in New York. Albert Einstein was a violinist, Bob Dylan and David Lynch make paintings, and Jerry Garcia makes artworks — paintings, drawings, watercolors, and prints. These people are not known and respected for what are considered their recreations. Still, the qualities of a recording of Albert Einstein's violin improvisations would reach beyond his celebrity status or his public history, into the area of his personality, his private reality. Far beyond the flat immediacy of a star's autograph, evidences of the pleasures and the unguarded musings of extraordinary people offer a direct resonance of their essential — human — nature, as well as an indirect overbrimming of their real genius.

Although Jerry Garcia was drawn to art as a possible profession, his major artform became music. But Jerry Garcia's cultural tradition, the counterculture of the American 1960's was, almost by definition, aesthetically polymorphous: if someone was a published poet and playwright, he might also be a devoted dulcimer-player; a classically-trained ballet dancer might be better known for her cartoons in an underground newspaper; a composer of electronic music could be found writing epic psychedelic poems in his native Polish. Jerry Garcia's art emerges fairly purely from this now decades-long experiment in human possibilities. They are visual improvisations, as unintentional and

as open-ended as a line of notes emerging from his guitar must be to be the right notes at the right time.

His art is made up, then, of anecdotes — stories of unusual people, humorous animals, imaginary landscapes, and fantastic architectures. His pieces are epigrams, expressions of quick wit, whose lightness and delight are surprisingly simple, given the darker complexities of the artist who made them.

Jerry Garcia has lived very near the center of a great cultural change that has drawn across every layer of late twentieth century society. The explosion of electronic media — vitally including popular music — has made the world over in the image of constantly shifting values and bewilderingly open awarenesses. The Grateful Dead is one of the transnational carriers of this wave of transformation, and Jerry Garcia has been a witness at the edge of this wave. His art has remained separate from that witnessing, except that it carries a wise humor and a childlike inventiveness. These artworks are not vanities, but represent, in a true sense, gentle pauses, quieter eddies in a very swiftly flowing current.

—*J.W. Mahoney*

J.W. Mahoney is a Washington D.C. artist and critic who survives by museum work and astrology. He is a 1972 graduate of Harvard University in art history, and his latest article, "DC Dreaming," appeared in the February, 1991 issue of *Art in America.*

I first met Jerry Garcia about 35 years ago, when he walked into a painting class for high-school students that I taught at the California School of Fine Arts (now the San Francisco Art Institute). He looked sturdy, innocent and street-wise, and I had the feeling that he had just finished reading "On the Road," and wanted to do something about it.

He and his friend, Mike Kennedy, threw themselves into the class work and thoroughly proceeded to paint up a storm. By doing this, they had "proven" themselves and were accepted into the underground social life at the Art school viz., end of week parties . . . parties given for the slightest reason . . . a check from home . . . the cat had kittens. . .

At these parties the school band sometimes entertained. The band was called the *Studio 13 Jass Band* and included Elmer Bischoff on trumpet, David Park on piano, Charlie Clark on clarinet and yours truly on banjo. The sound was loud and a mixture of Dixieland. Traditional New Orleans Jazz and lots of Blues.

People ask me, "What do you remember about Jerry Garcia at that time?," well there is one vague memory of one of the above impromptu parties . . . it was dark and noisy . . . the band was deafening in the echoey "Social Hall" . . . the floor bounced as people "danced". . .

I looked up and saw Jerry staring at my hands as I played . . . when the tune ended, he came up to me and said "What is that thing you're playing?" I said, "It's a banjo." He asked, "What are you doing with your fingers?" and I answered, "I'm playing the chords . . ." He said, "Oh, uh . . . do you think I can learn to do that?(!)" I don't know what I answered, as Elmer stomped off a fast blues and chaos descended on the room and the evening.

But obviously Jerry answered his own question, because the vague, vivid memory that I have of him was when I was running in the Pan Handle on a Sunday and noticed a crowd standing around a flat-bed truck with a portable generator putting in the bushes.

There he was . . . playing a great big electric guitar and wailing the blues at about 110 decibels. The band played . . . the crowd danced and I ran on . . . thinking, "Hum, I wonder if Jerry paints anymore. . . ?

Time passed . . . acid test . . . Beatles . . . Vietnam . . . Marin . . . Reagan. . .

Recently, a friend told me that Jerry Garcia is having a show at The Art Peddler Gallery . . . and I say to myself, ". . . I know that kid had 'it' and it makes me feel good to say it."

He was painting and drawing, all that time . . . I shouldn't have worried and "He had it." And now we're going to get the opportunity to share that "it-ness" with him. . .

Thanks Jerry!

Wally B. Hedrick
Bodega, CA 1992

A toe at a time wings
are sometimes hidden there's
a valley at the end of every
desert

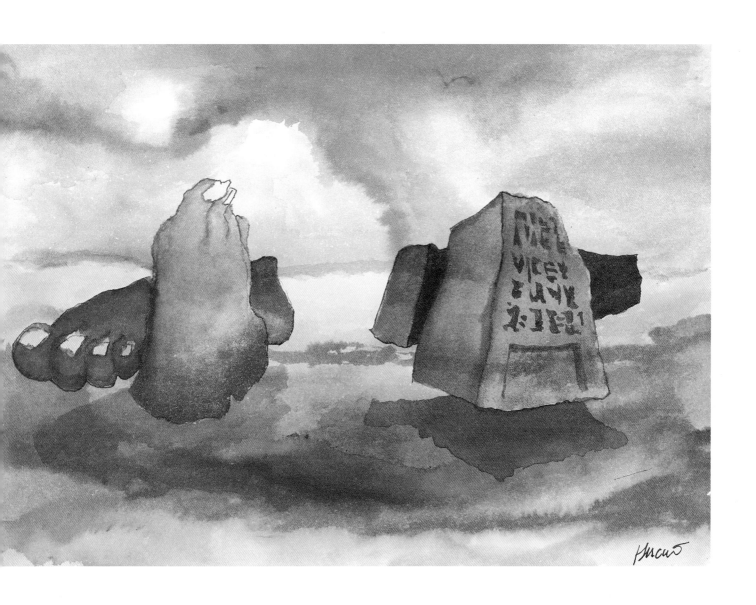

Hieroglyphics
10" x 7"
Ink and Watercolor
13

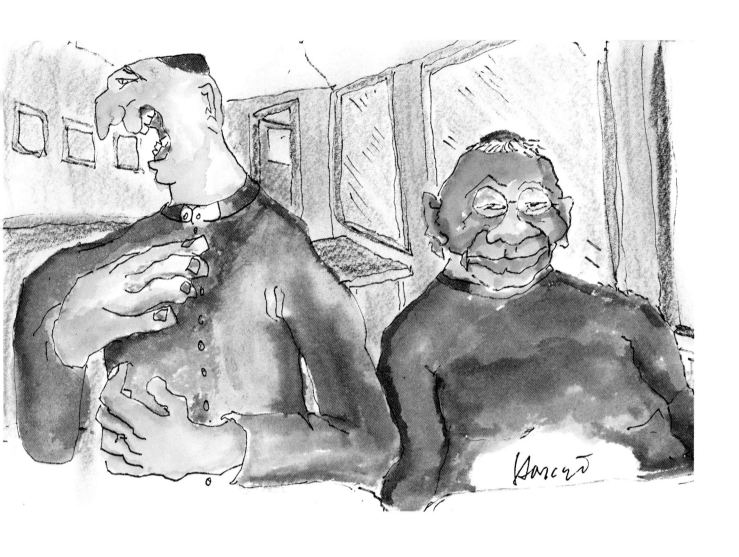

The Cardinals 1991
5" x 7"
Ink and Watercolor *15*

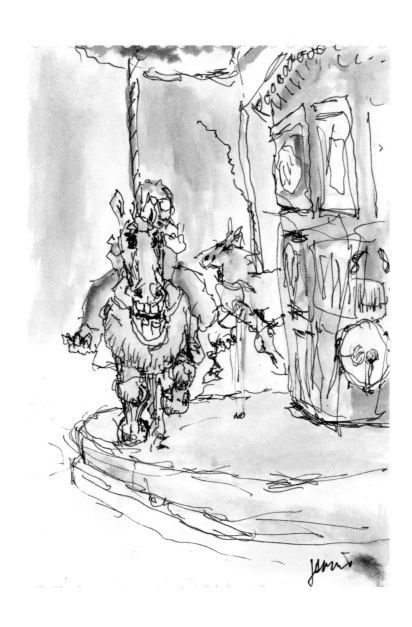

Carousel 1990
4" x 6"
Ink and Watercolor

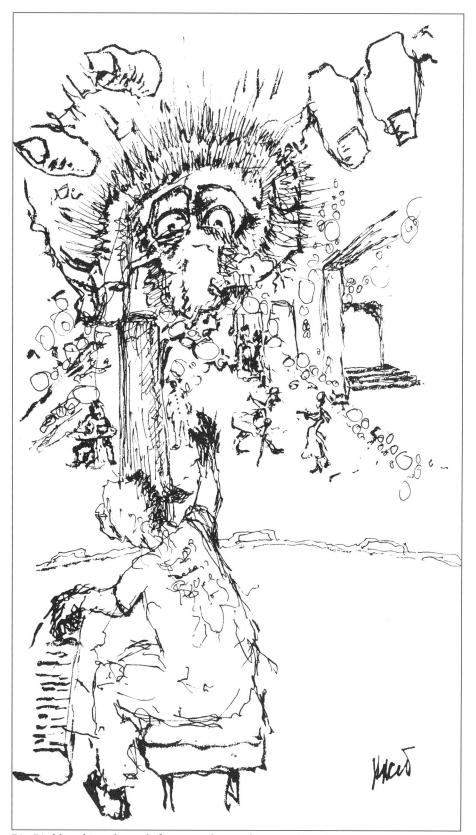

Big Bird breaking through from another reality to get Mr. Roger's piano player.

1990
5" x 8"
Ink *17*

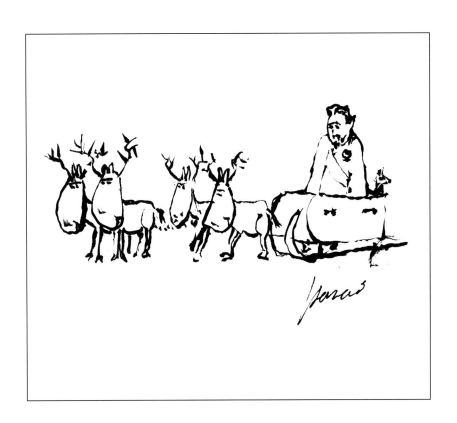

Dracula-Claus 1990
5" x 3"
18 Ink

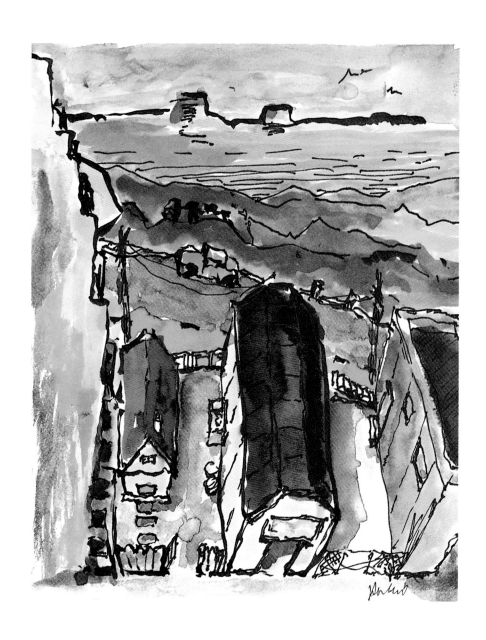

Poet Absorbs the War 1991
9" x 12"
20 Watercolor

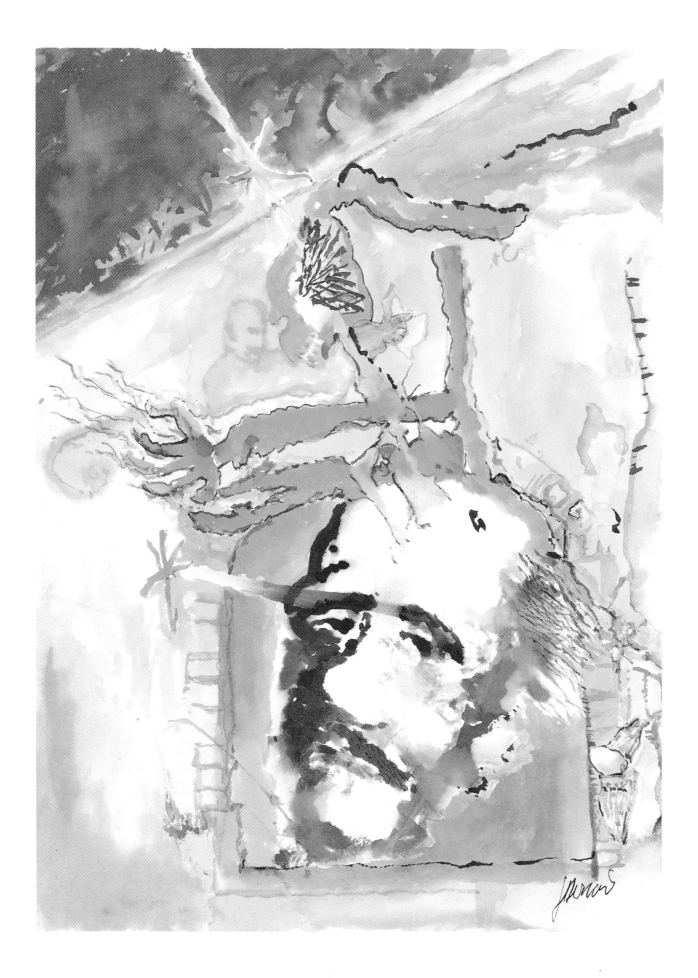

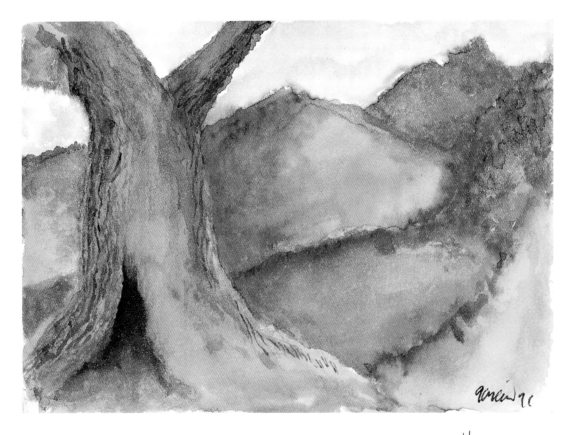

Green Landscape 1991
6" x 4"
22 Watercolor

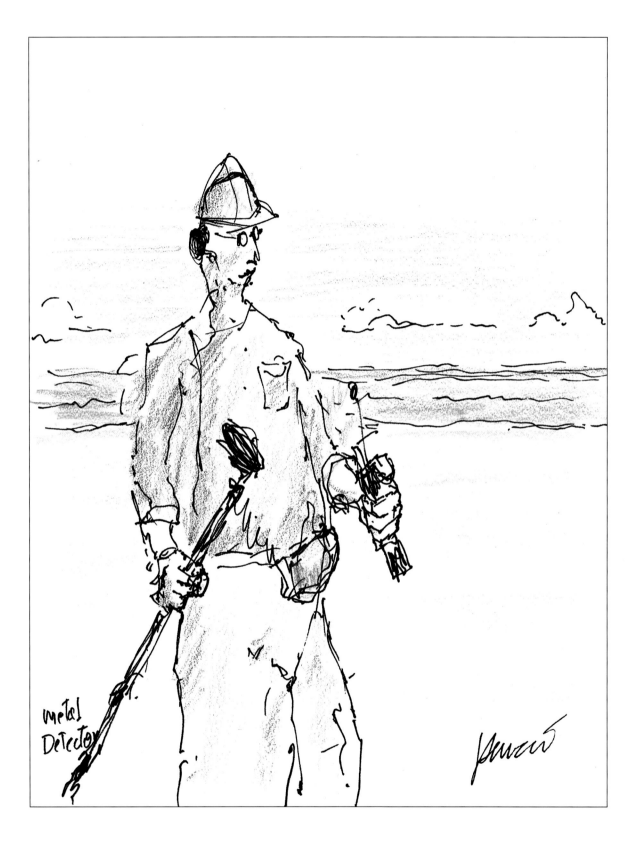

metal
Detector

Metal Detector 1991
6" x 8"
Ink and Colored Pencil 23

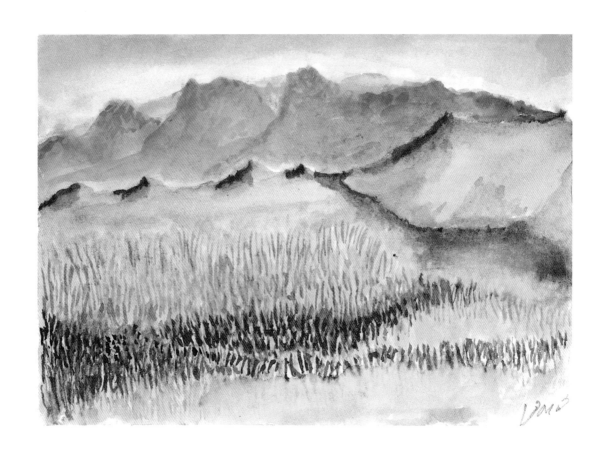

Red Meadow 1991
6" x 4"
24 Watercolor

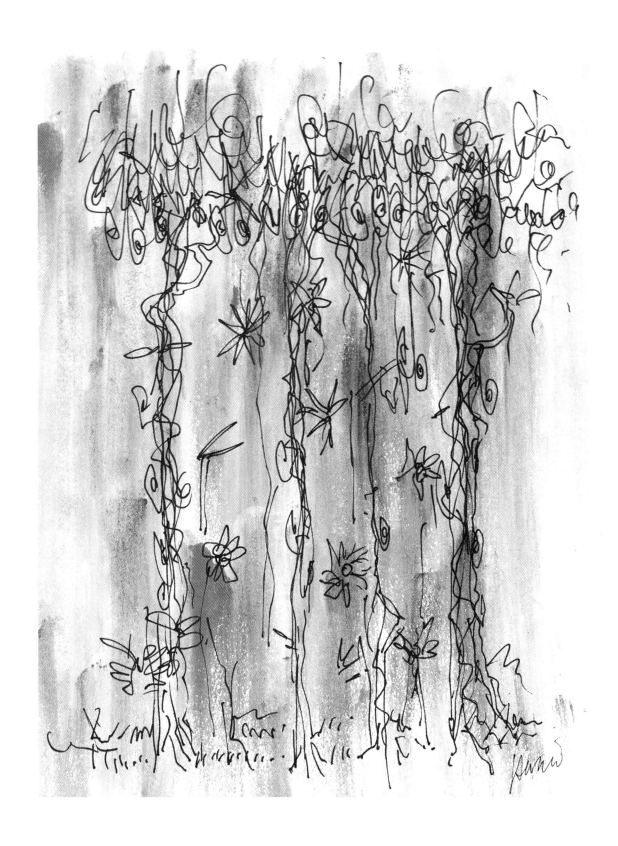

Banyan Trees 1991
6" x 8"
Ink and Watercolor *25*

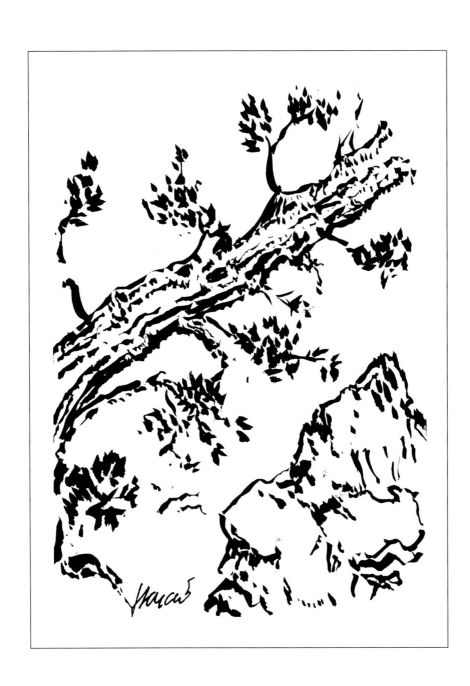

Pine and Rock 1991
4" x 6"
26 Ink

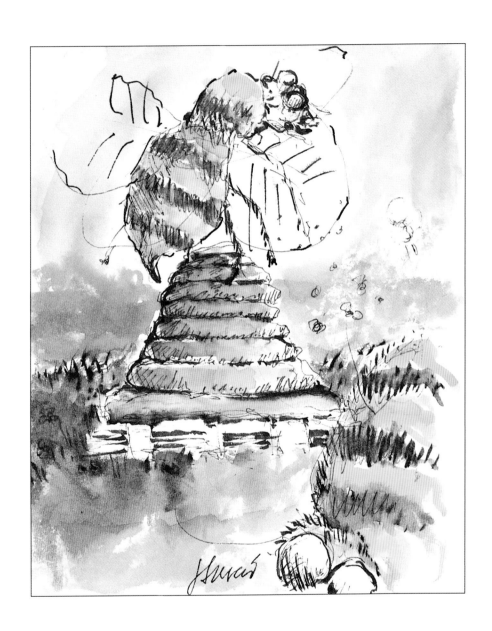

Bee Hive 1991
4" x 6"
Ink and Watercolor 27

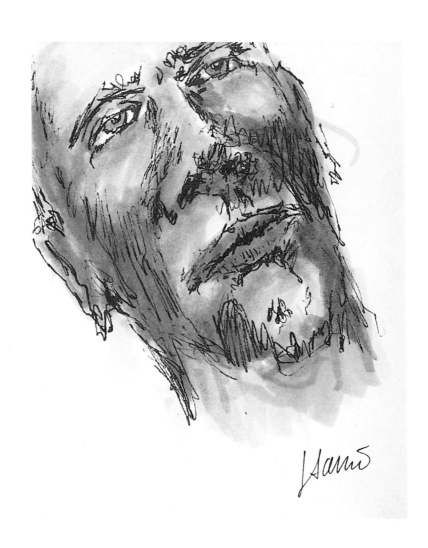

Blue-Eyed Man 1986
4" x 6"
28 Ink and Colored Marker

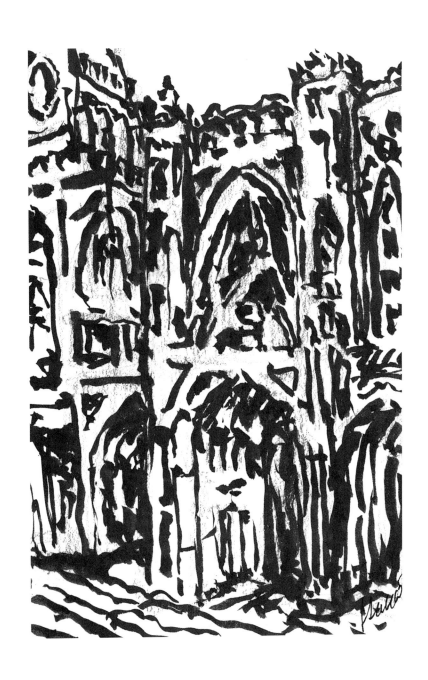

After Monet 1990
4" x 6"
Ink *29*

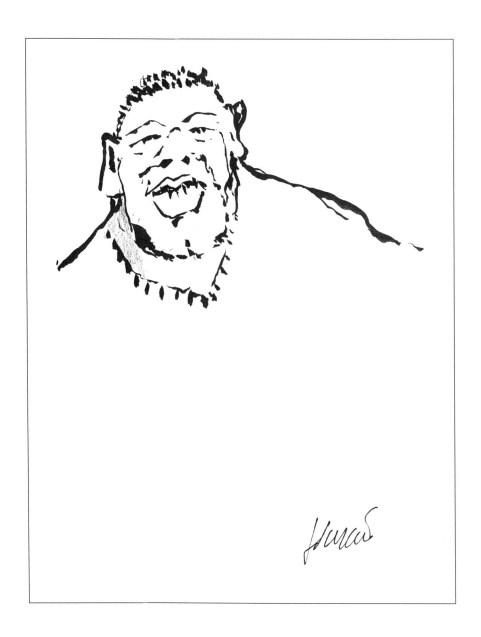

Homeboy 1990
4" x 6"
32 Ink

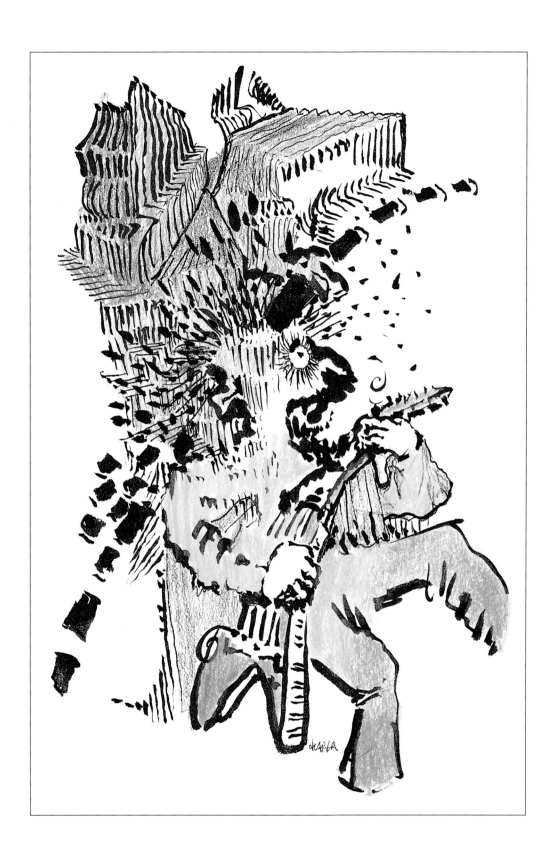

Wired Crossroads 1990
5" x 8"
Ink and Colored Pencil 33

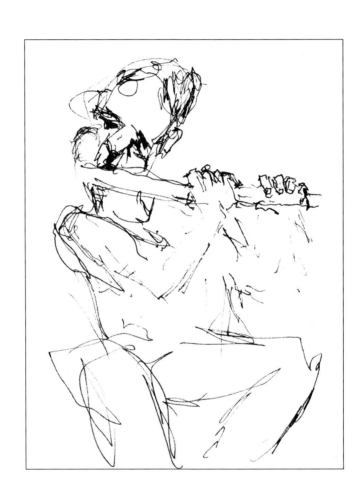

Flautist 1986
4" × 6"
34 Ink

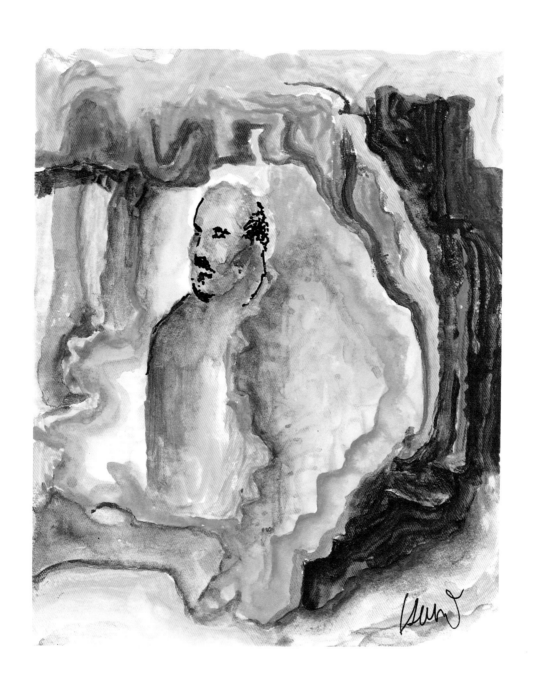

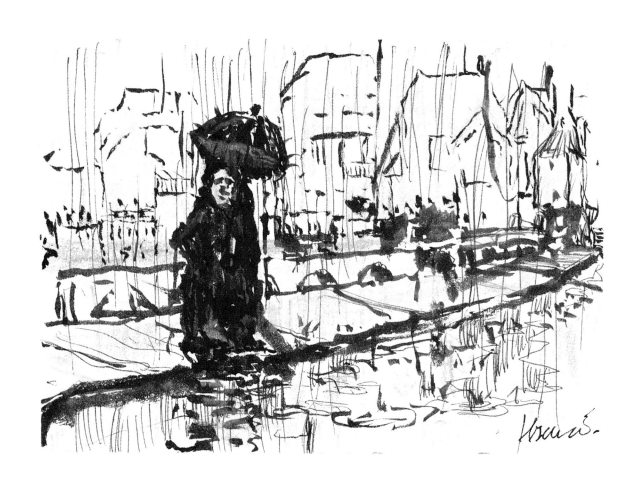

Paris in the the Rain 1991
6" x 4"
36 Ink and Watercolor

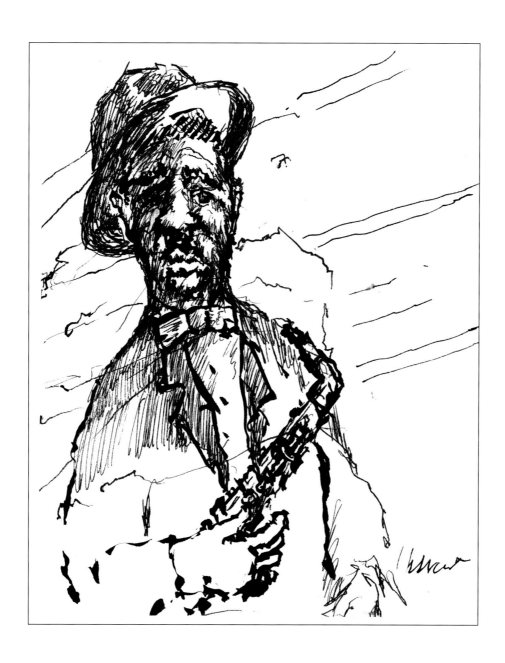

Zoot 1991
4" x 6"
Ink *37*

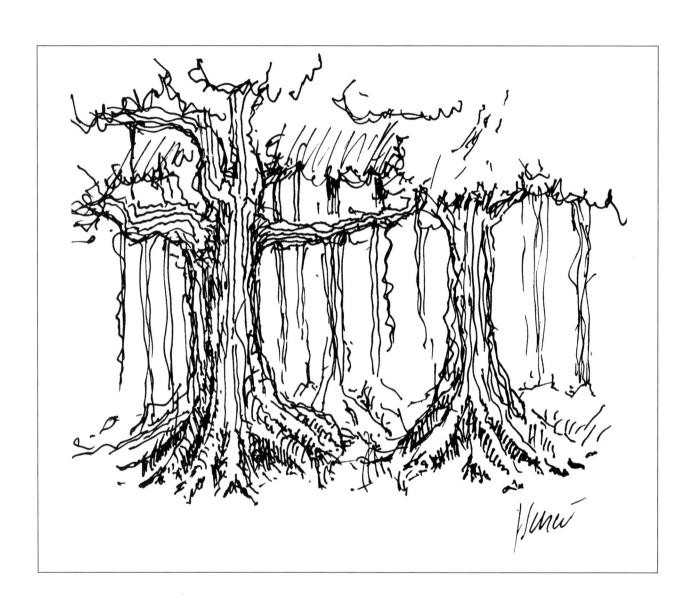

Banyan Forest 1991
6" x 5"
38 Ink

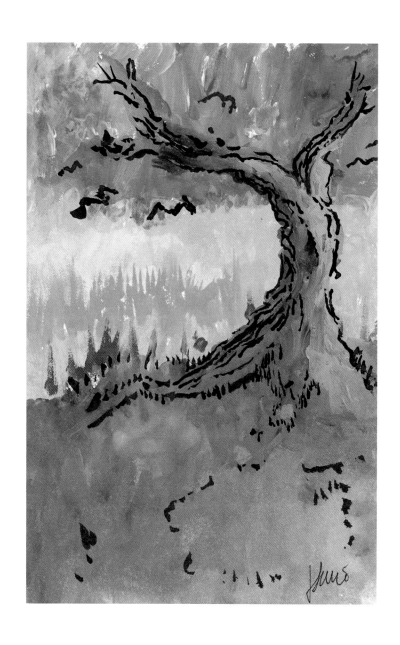

Van Gogh's Tree 1990
4" x 6"
Ink and Watercolor *39*

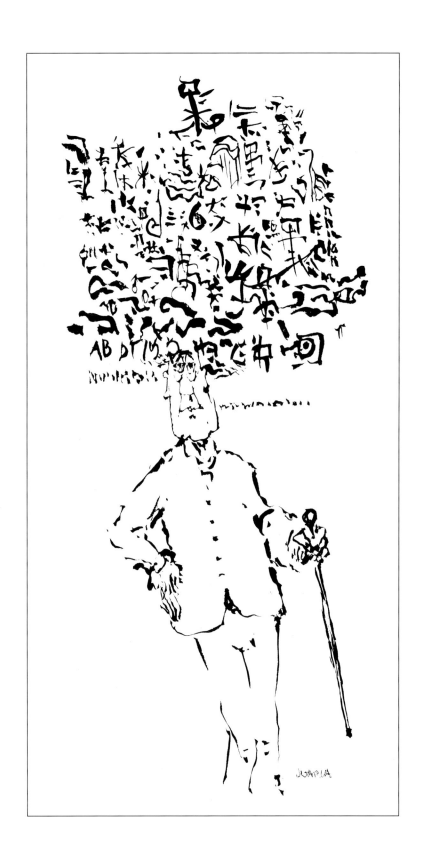

Abstracted 1990
4" x 8"
40 Ink

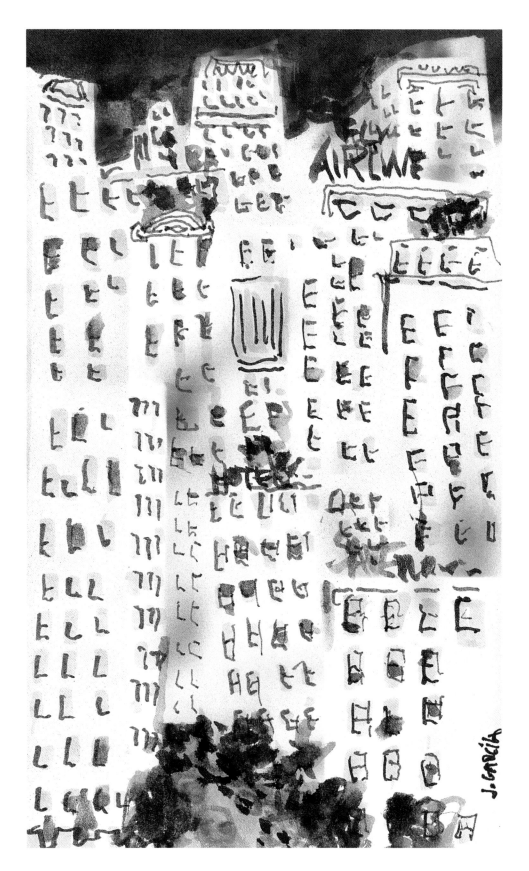

New York, NY 1985
5" x 8"
Airbrush Colored Marker **41**

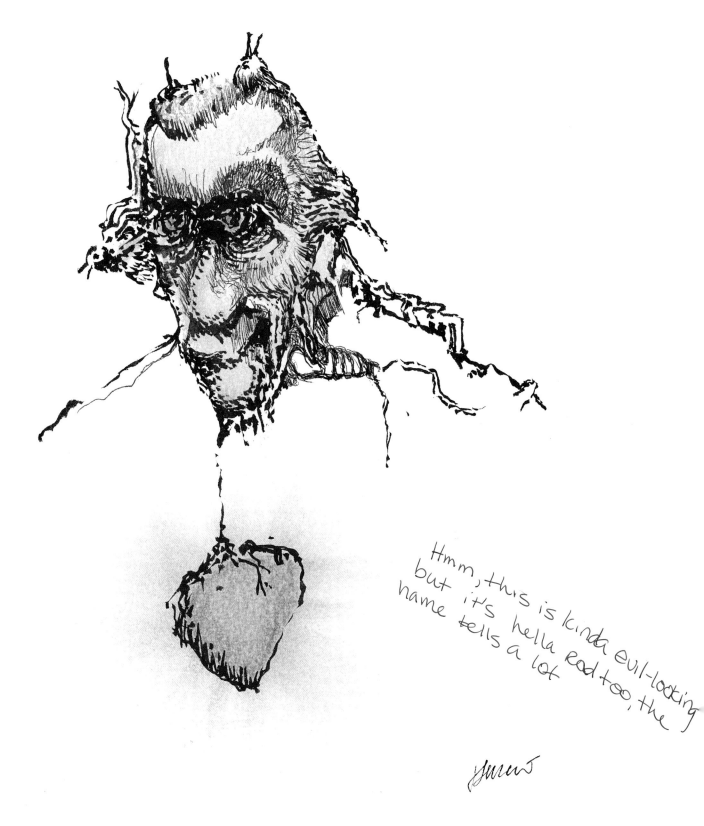

Hmm, this is kinda evil-looking but it's hella rad too, the name tells a lot

Thirsty 1991
7" x 9"
Ink and Watercolor 43

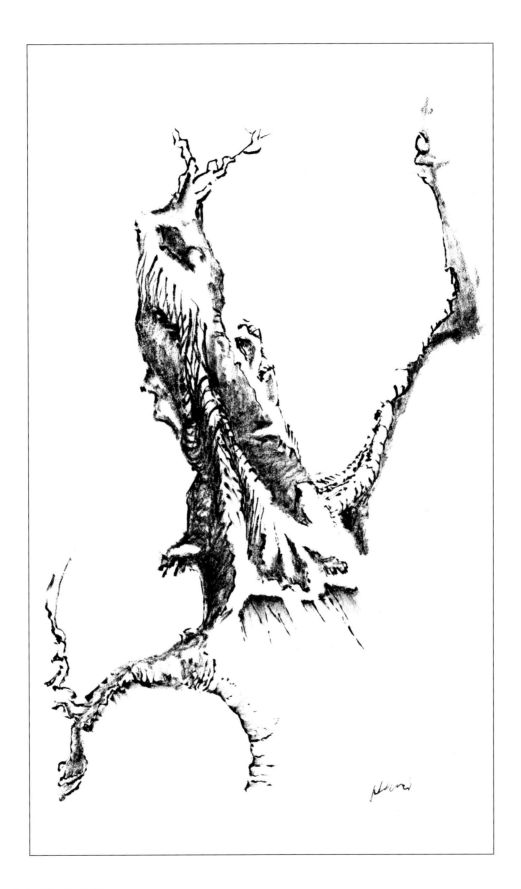

Not Quite Wood 1989
5" x 7"
Ink

44

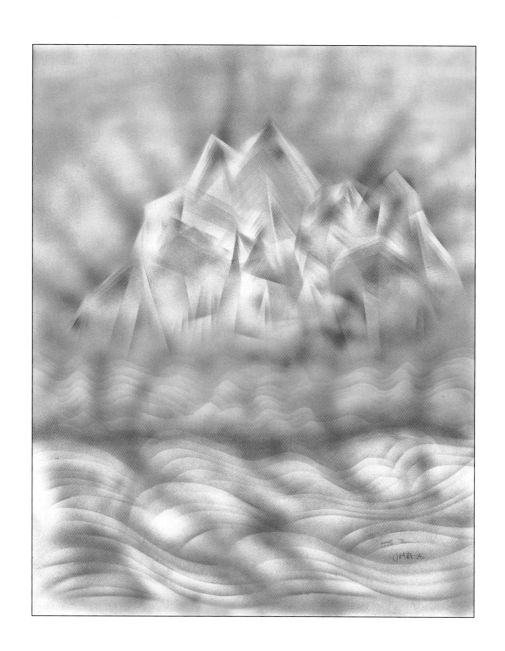

The Blue Iceberg 1986
19" x 24"
Airbrush Acrylic *45*

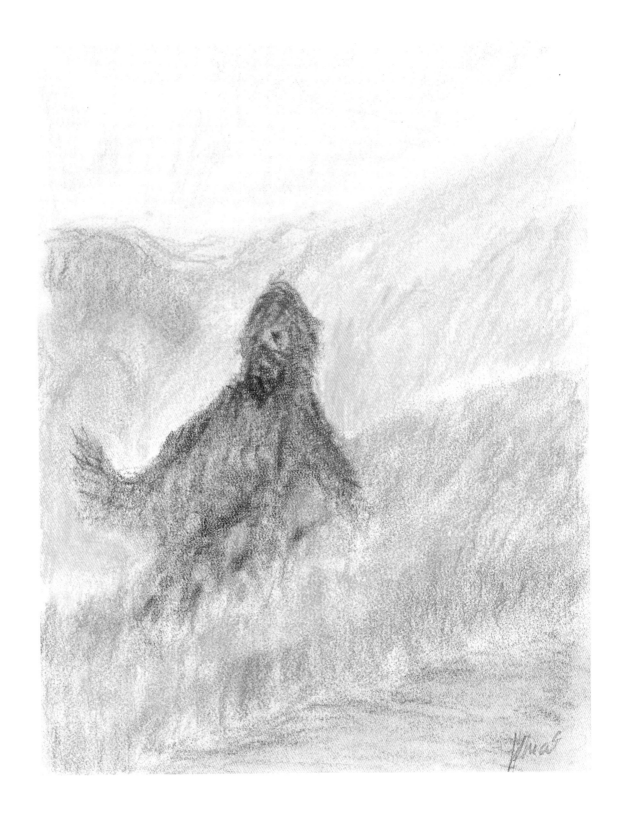

Doggie 1991
6" x 8"
46 Colored Pencil

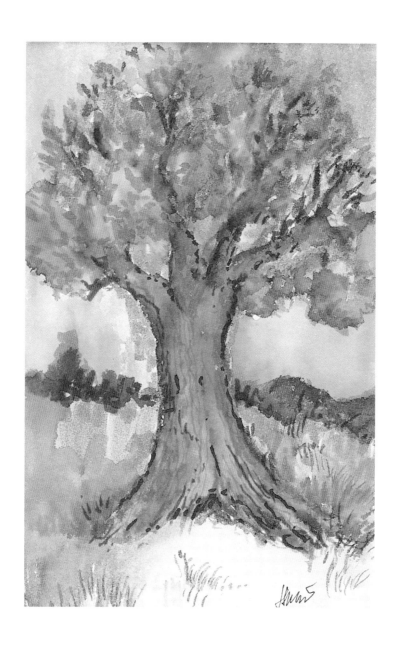

Oak Tree 1990
4" x 6"
Watercolor *47*

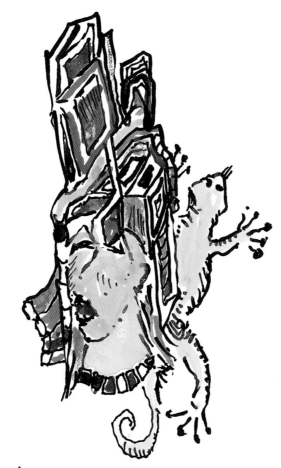

ʃLADY w/ ELADoRAIE HeAdness
 é gekko

Lady with Elaborate Headress and Gekko 1990
4" x 6"
48 Ink and Watercolor

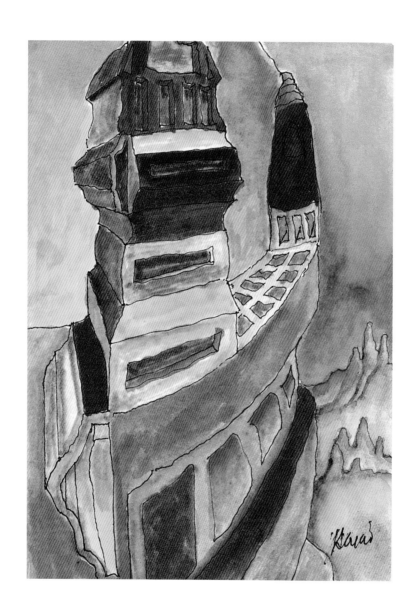

Untitled 1990
4" x 6"
Ink and Watercolor 49

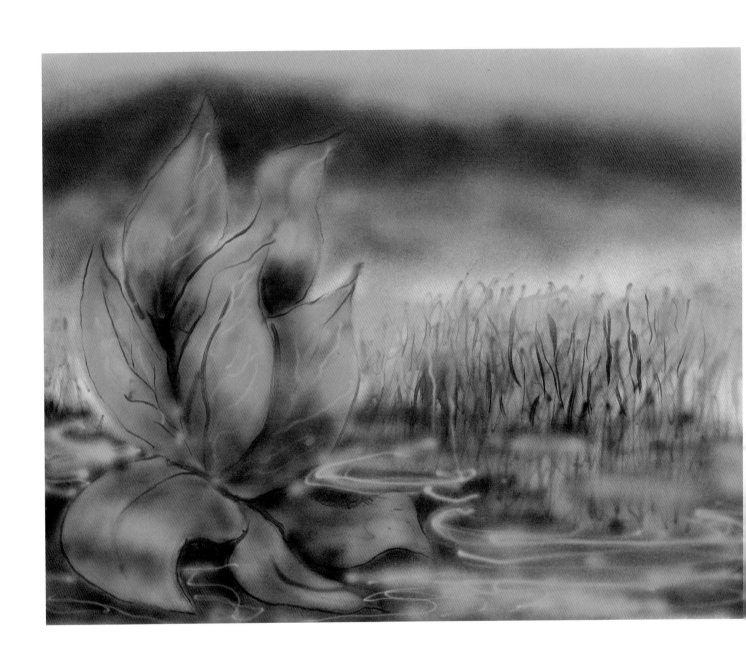

Wetlands II 1986
24" x 19"
50 Acrylic Airbrush

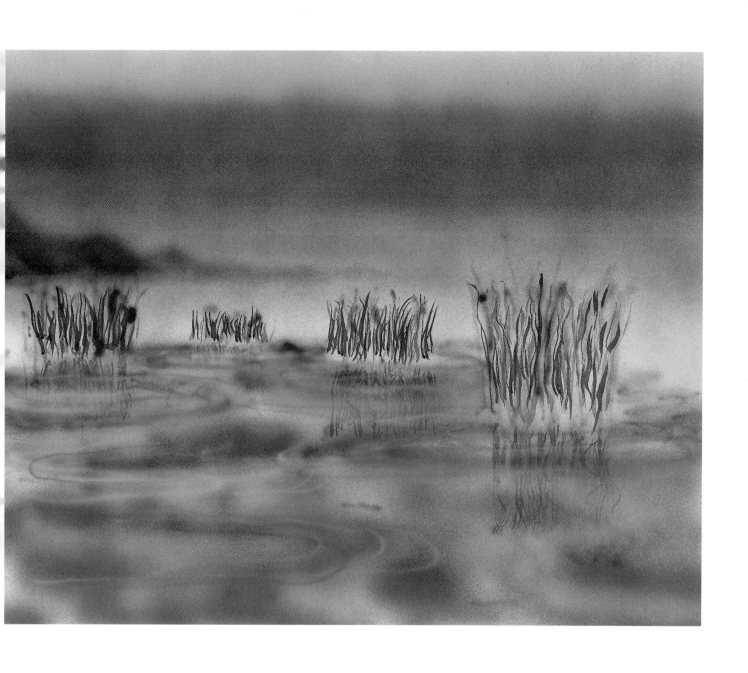

Uncorrected Manuscript 1989
4" × 6"
52 Ink

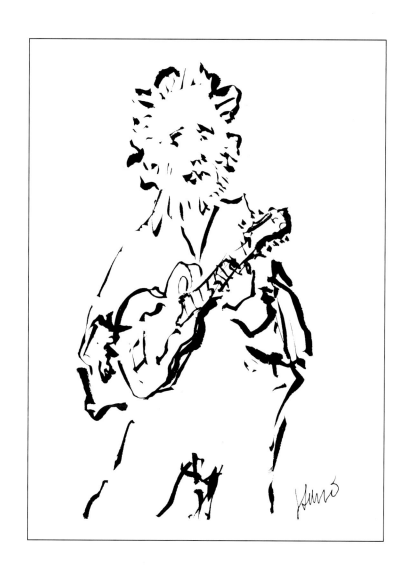

David 1990
3" x 5"
Ink *53*

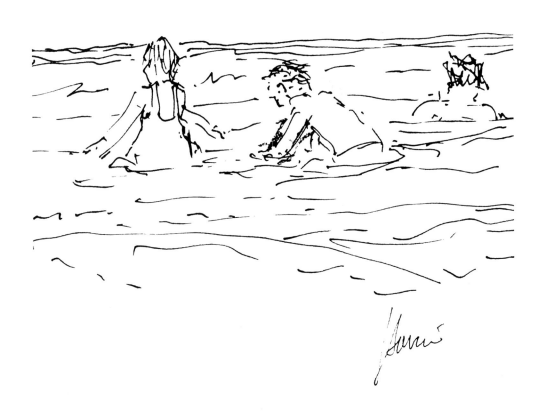

Bathers 1990
6" x 6"
Ink

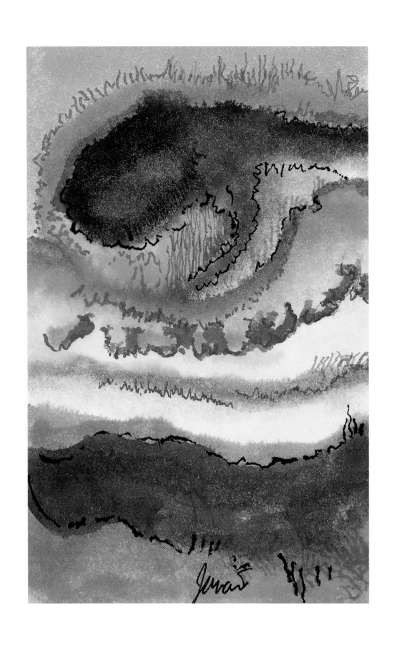

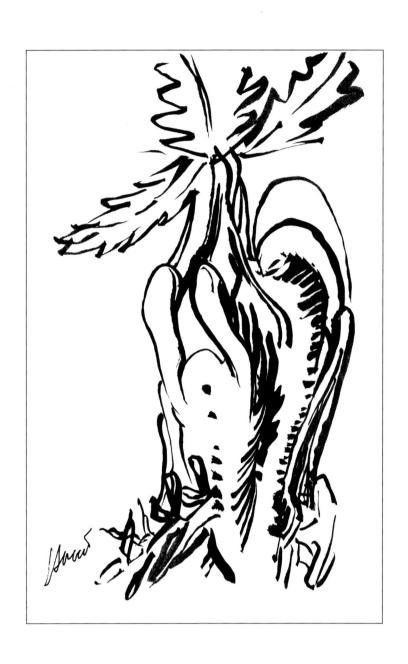

Plant Person 1990
4" x 6"

56 Ink

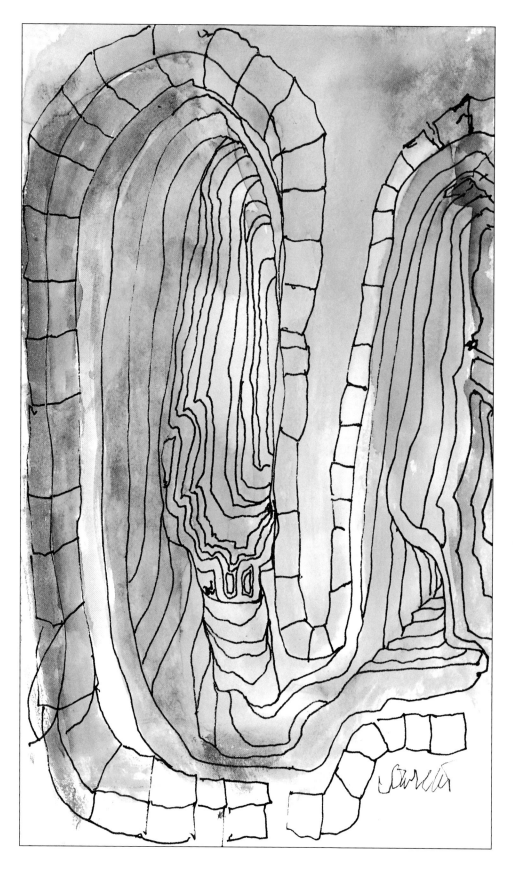

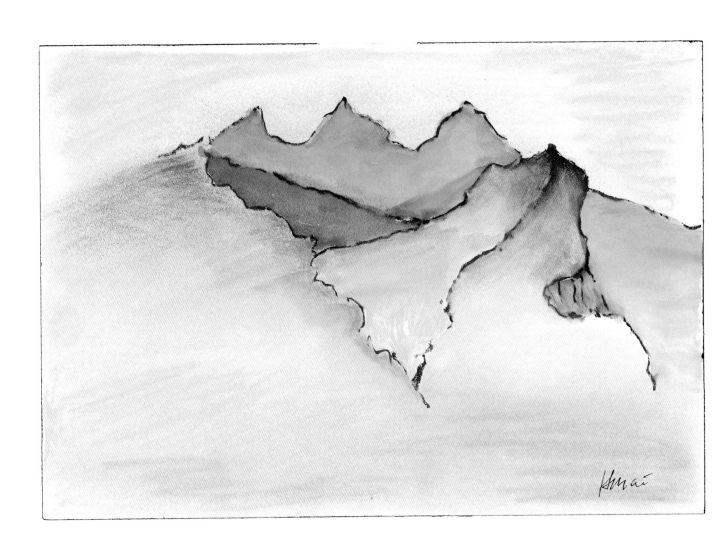

Landscape 1991
10" x 7"
Watercolor

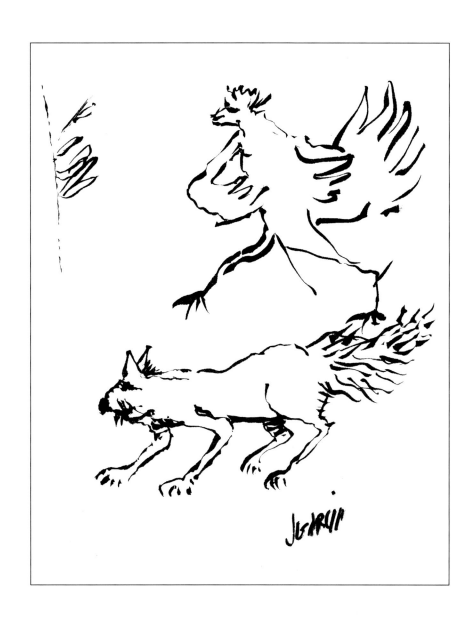

Chicken and Cat 1990
4" x 6"
Ink 59

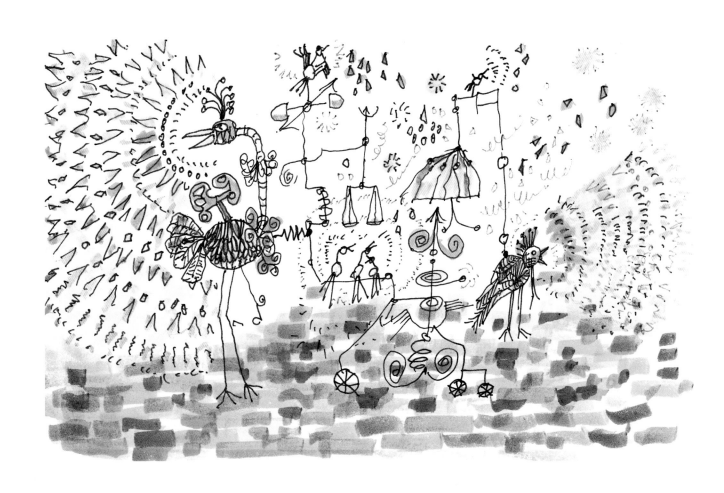

Like the Twittering Machine (for Paul Klee) 1985
7" x 5"
Ink and Colored Marker

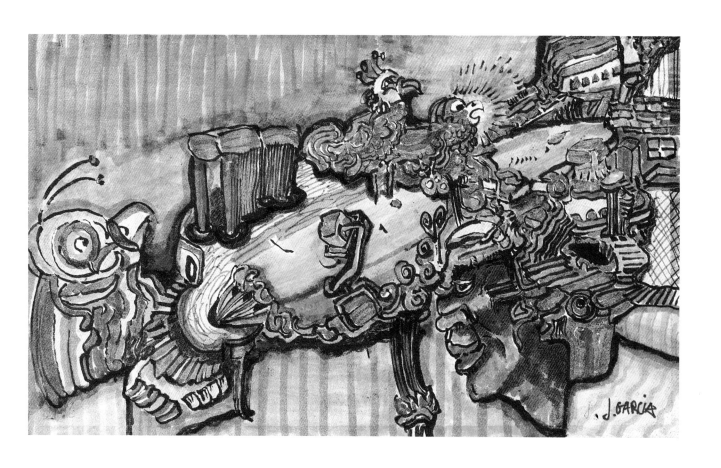

Birdland 1985
7" x 5"
Ink and Colored Marker 61

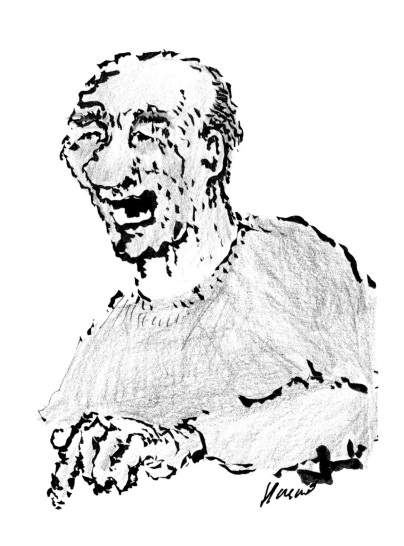

Bukowski 1991
4" x 6"
62 Ink and Colored Pencil

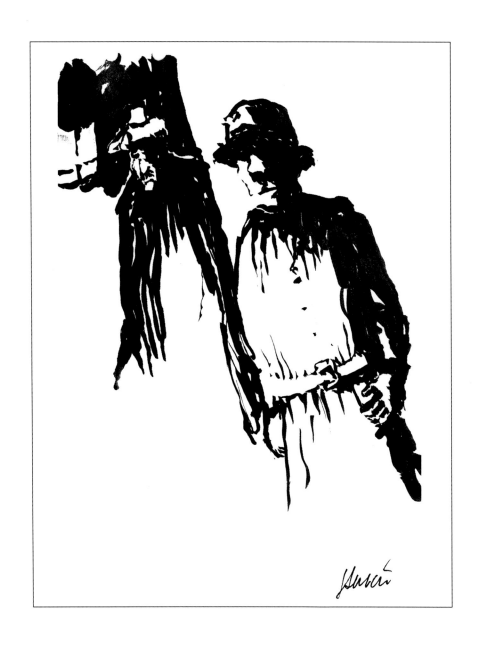

Film Noir 1990
4" x 6"
Ink 63

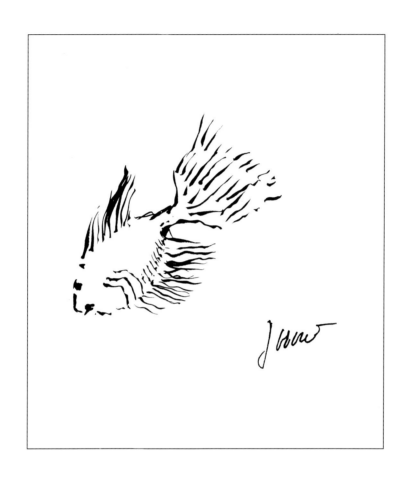

Little Fish 1991
3" × 3"
Ink

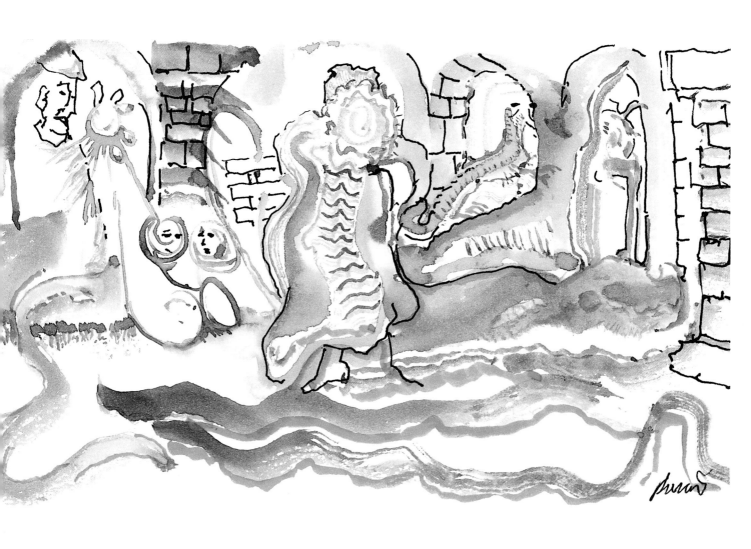

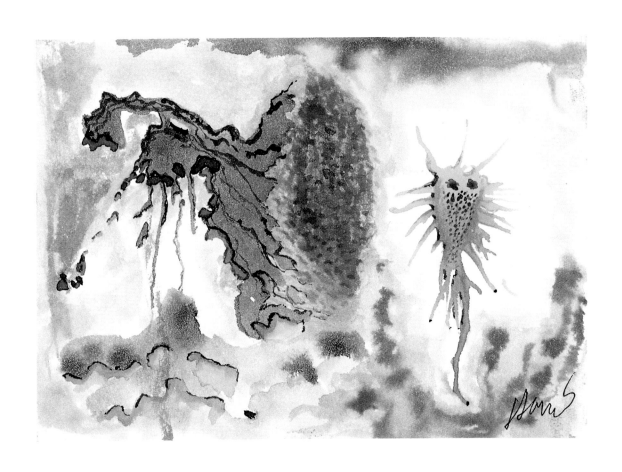

Thistle Ghost 1991
6" x 4"
Watercolor

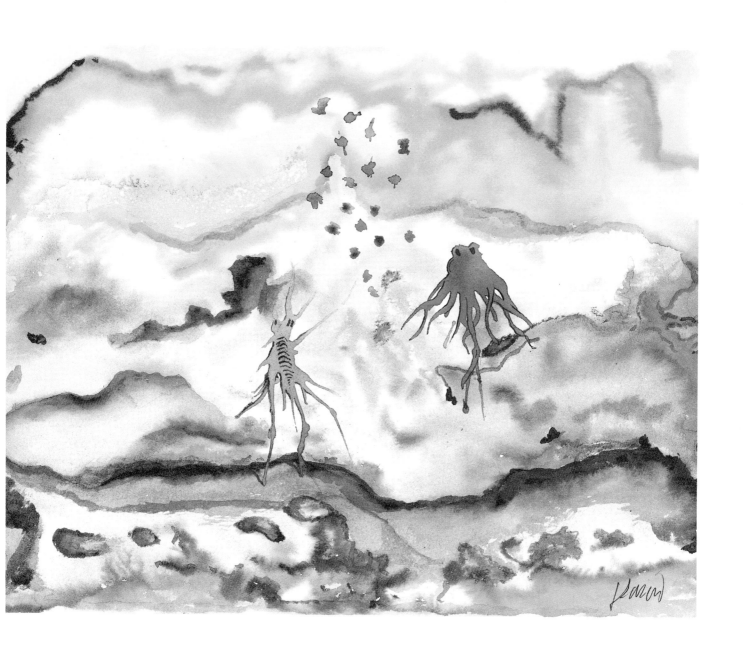

Drummers 1991
9" x 12"
68 Watercolor

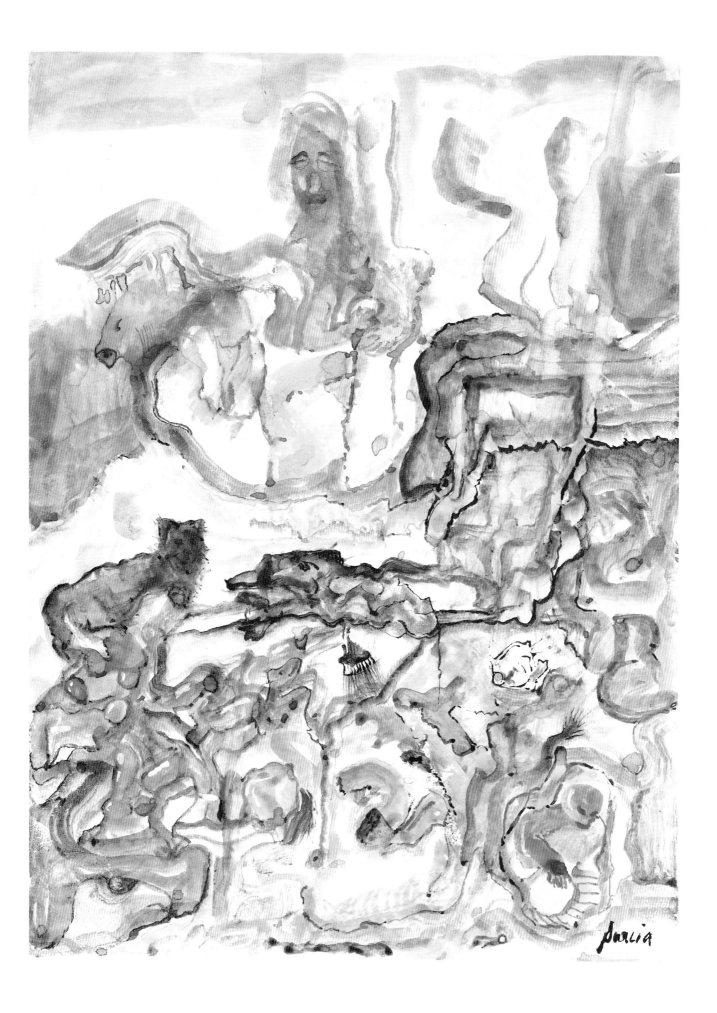

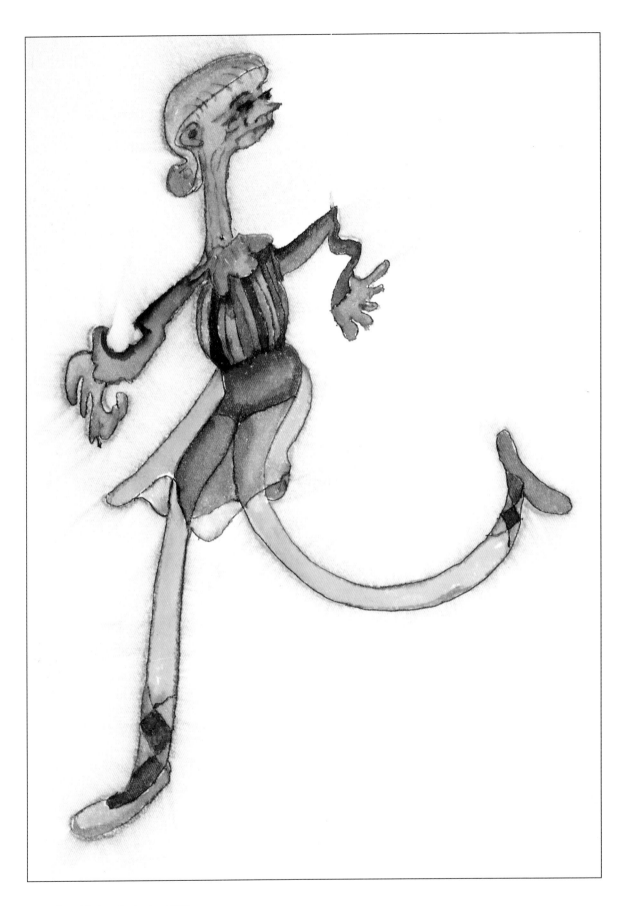

Lady with Argyle Socks 1991
6" x 9"
70 Ink and Watercolor

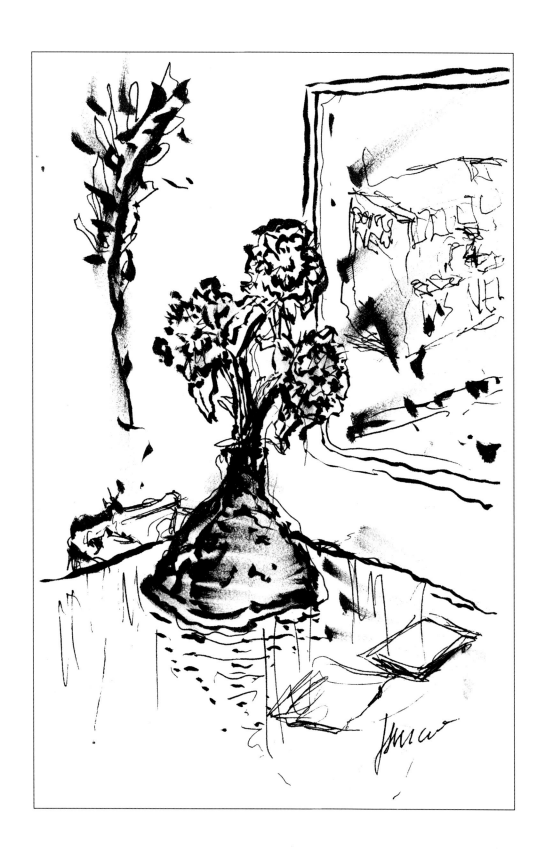

Still Life 1991
5" x 8"
Ink *71*

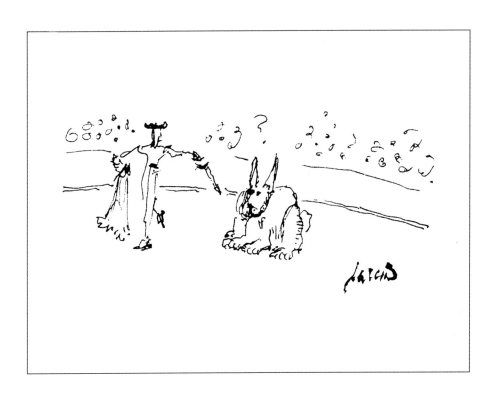

At the Bunny Fights 1990
5" x 3"
Ink

72

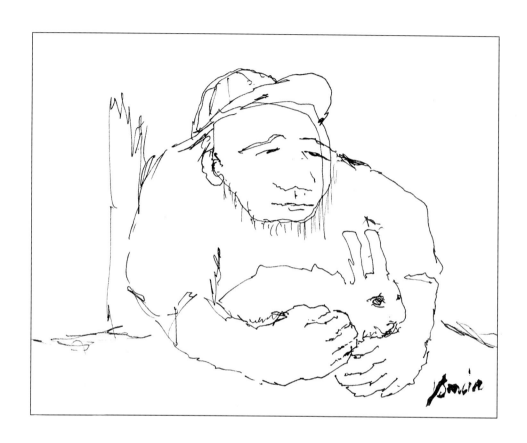

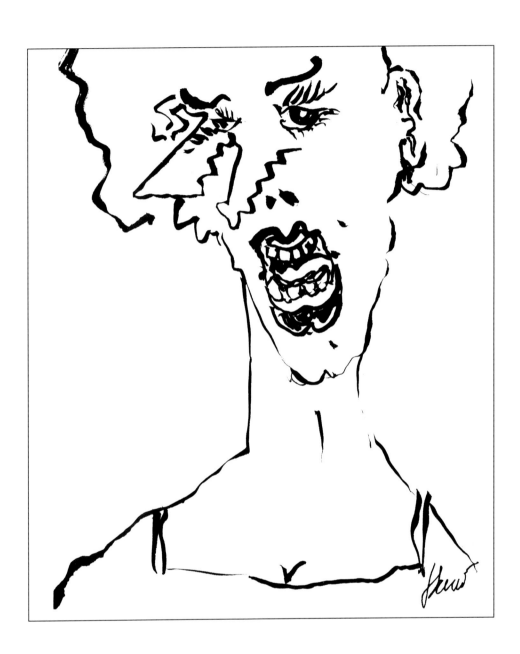

Scold 1991
5" x 6"
74 Ink

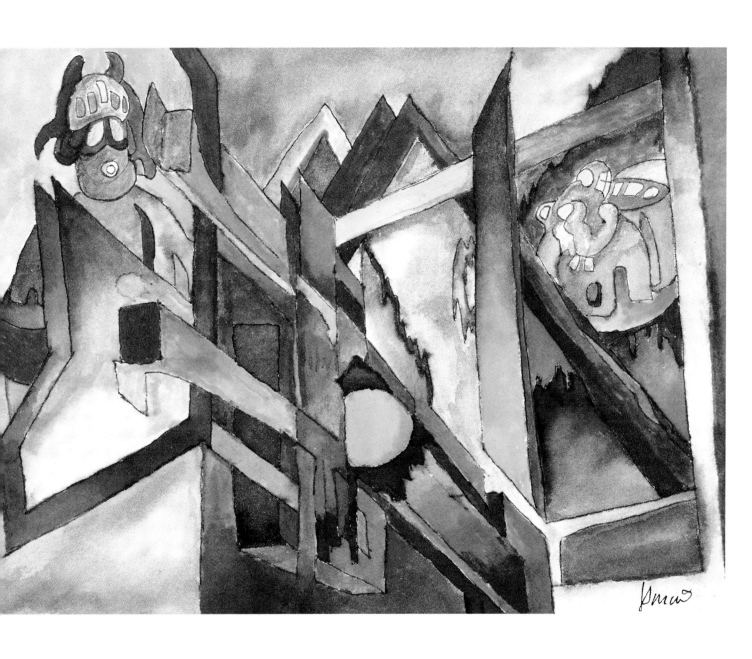

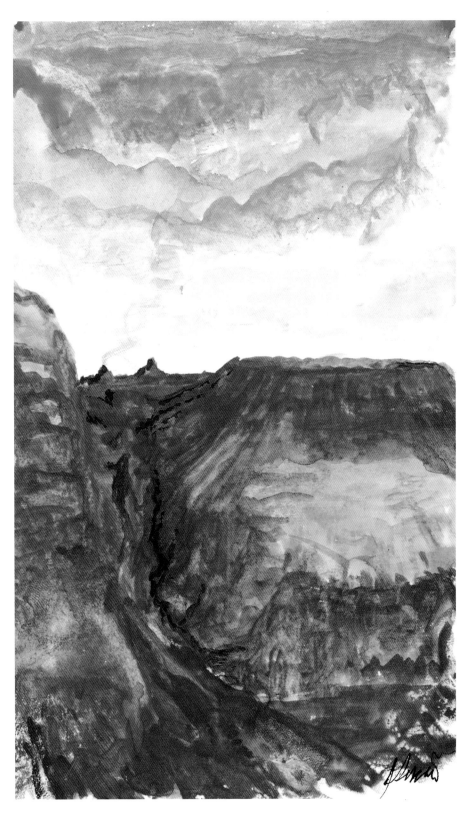

Smoke Signal 1990
5" x 8"
76 Watercolor

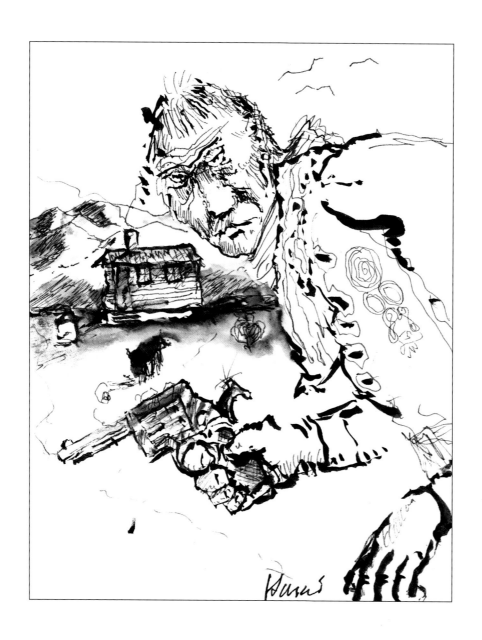

Desert Storm 1990
9" x 12"
78 Watercolor

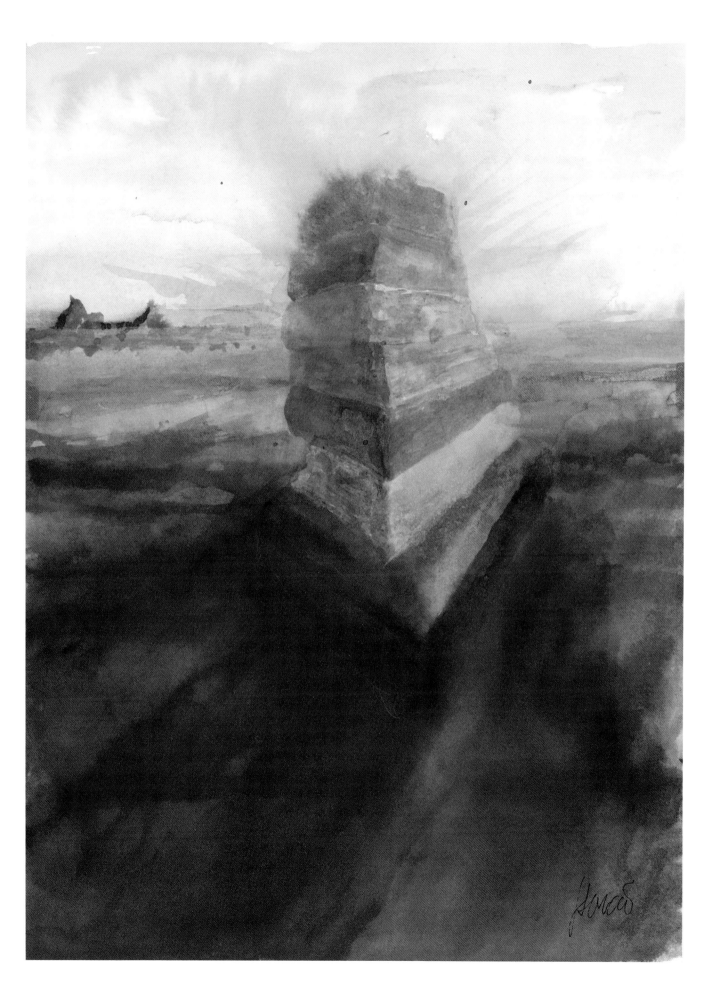

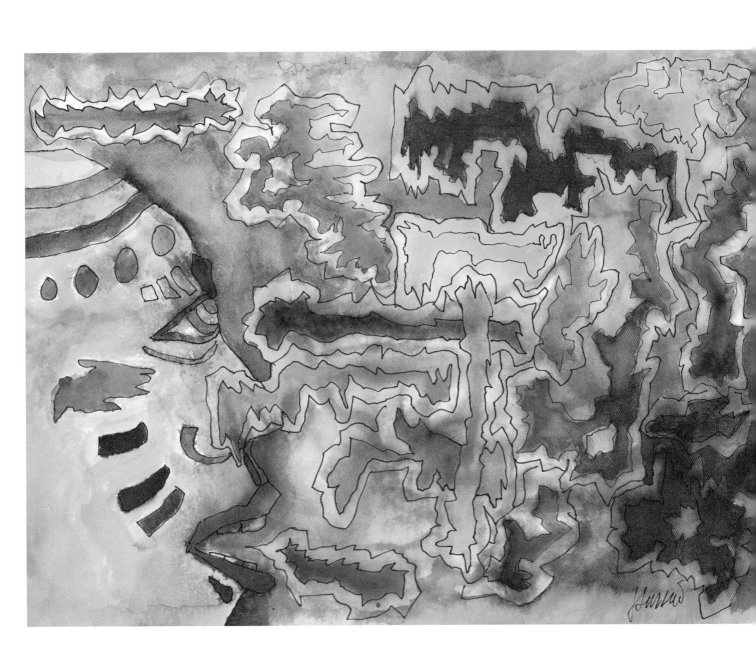

Shaman 1990
12" x 9"
80 Watercolor

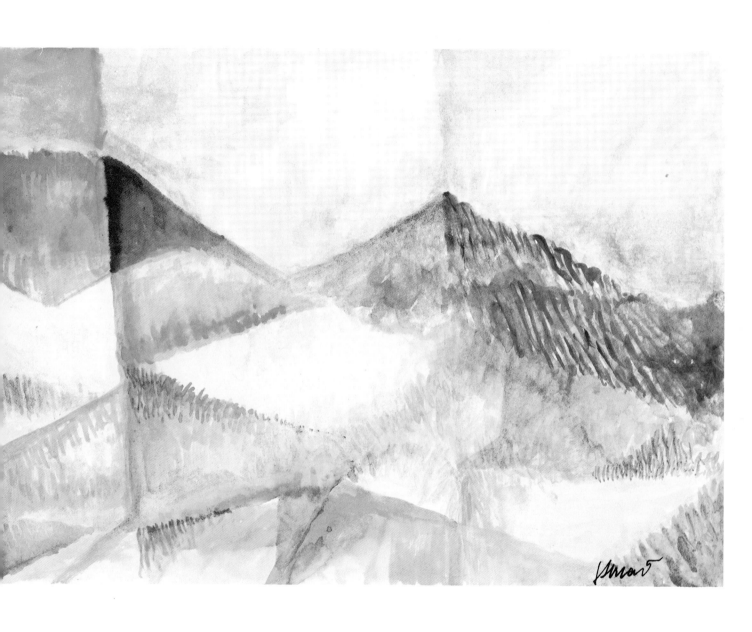

Blue Mountain 1991
12" x 9"
Watercolor *81*

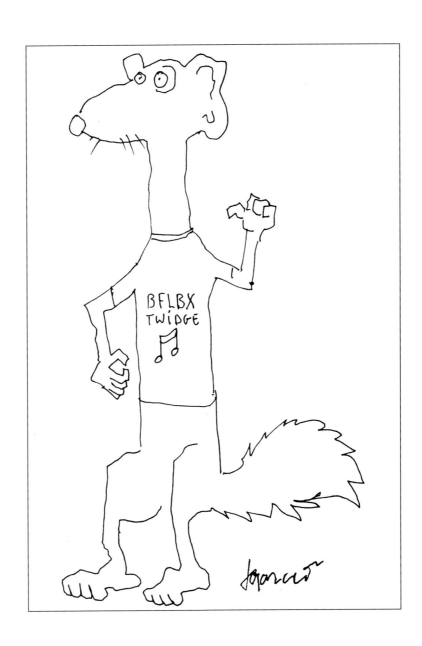

Mr. Twidge 1991
4" x 6"
82 Ink

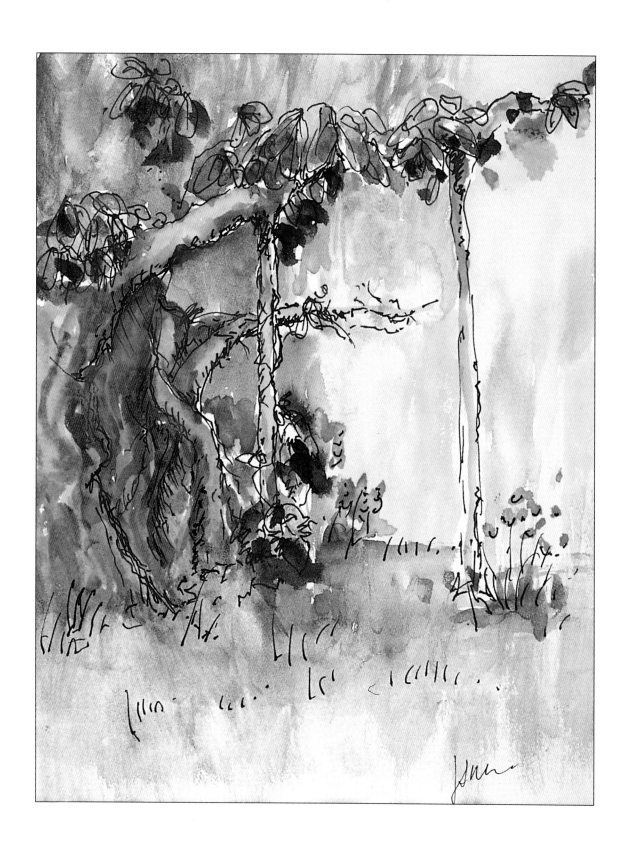

Banyan Trees II 1989
6" x 8"
Ink and Watercolor *83*

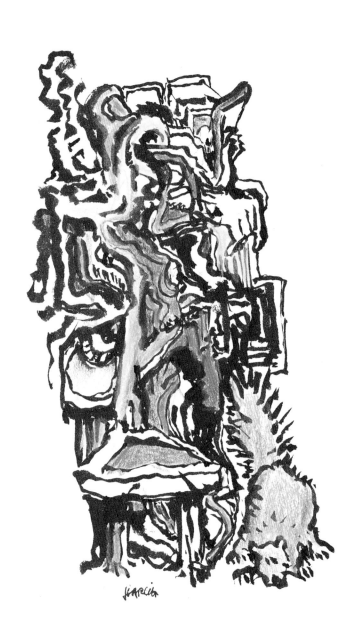

Squirrel Maze 1990
3" x 5"
84 Ink and Colored Pencil

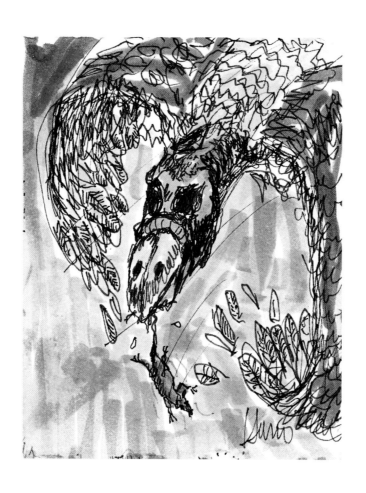

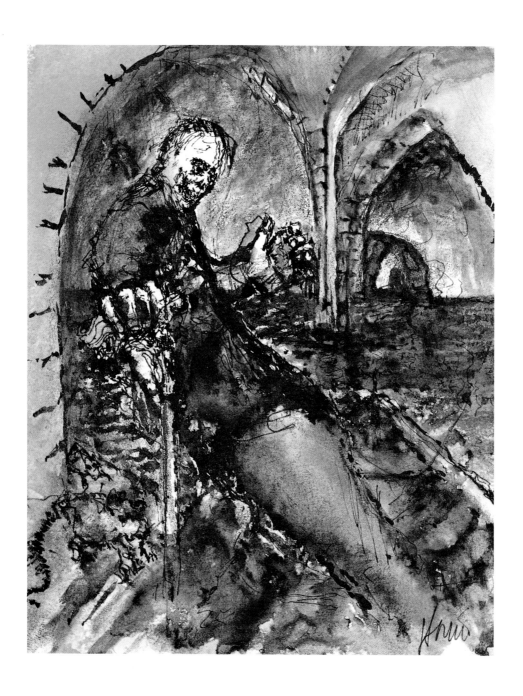

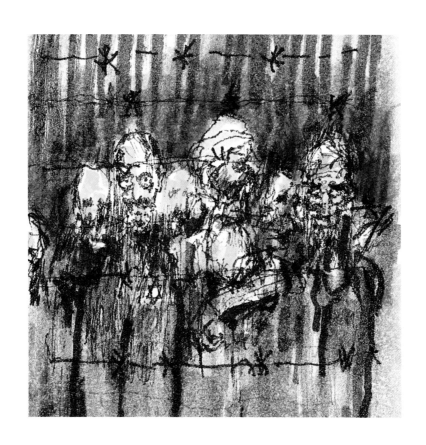

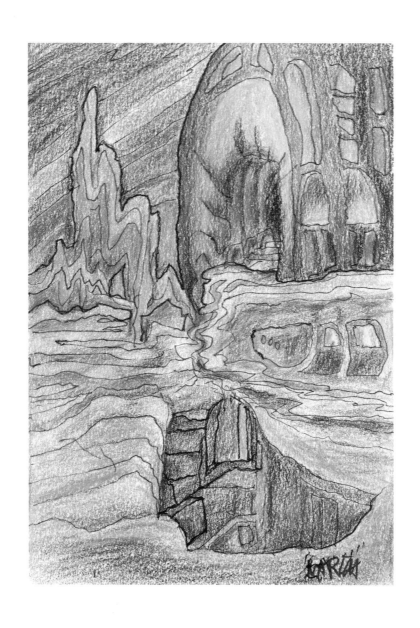

Northern Lights 1990
4" x 6"
Ink and Colored Pencil *91*

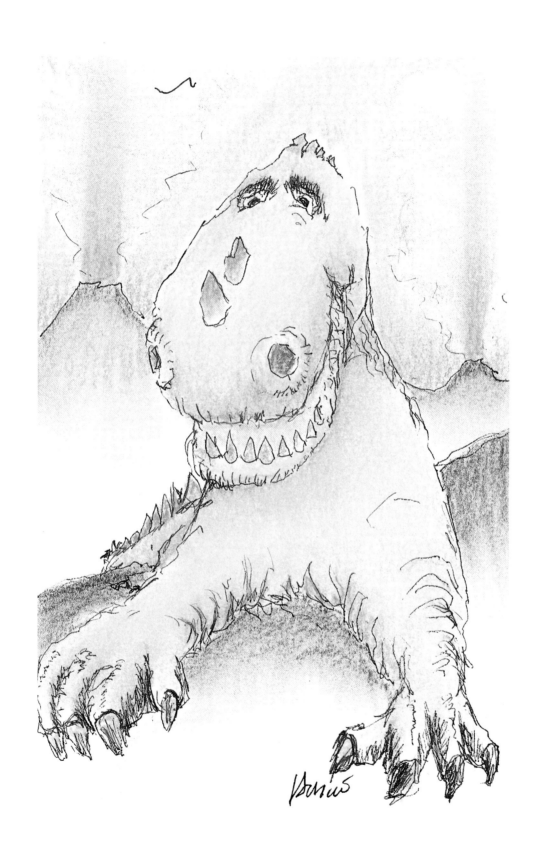

Garcia and I first met on Grant Avenue in the North Beach section of San Francisco, sometime in 1965. We were playing guitar and singing folk songs on Hoot Nite at the Coffee Gallery, during what Garcia refers to as "The Great Folk Scare," when folk music "almost became popular." It is one of my favorite stories, of the old days, that at one time and place, I got paid as much as Jerry or Janis for getting on stage and performing . . . free beer on Hoot Nite, Monday.

Those were the innocent days, then things happened. In an amazing succession of events, in a remarkably short period of time, freaks, beatniks and street people became international celebrities.

First time I heard the name "Grateful Dead" I thought "What kinda name is THAT for a rock and roll band?" After I got a few things straight, like drawing posters that reversed all the rules I learned in art school, I did alright by myself as an artist while Jerry did very well as a musician.

Garcia was a student at the San Francisco Art Institute in 1958–59, (I was a student there in 1960–61) and he has never stopped drawing and painting for his own pleasure. Garcia has recently entered the professional art arena and is doing very well . . . on my turf. Looks like it's time to dust off my guitar.

Victor Moscoso
Woodacre, Calif.
3-8-92

Contributing Collectors

Russell Brand
Sturgis Chadwick
Jeff Cohen
Tom Cosgrave
Elizabeth Decker
Tom DiGiacomo
Tim & Elizabeth Duncan
Donna Feldman
Will Freydberg
Kristine Gaier
Peter & Ginny Harris
David & Julia Kay
Fred Kufta
Howard LeClerer
Keith Miller
The Mortenson Family
Richard Nissak
Ned Parslow
David Starr
Bruce Stilson
Orlando Toro
Julie Wolf

For information regarding Limited Edition Prints please contact The Art Peddler, P.O. Box 1371, San Rafael, CA 94915.